Terry Harrison's
Sea & Sky
in Watercolour

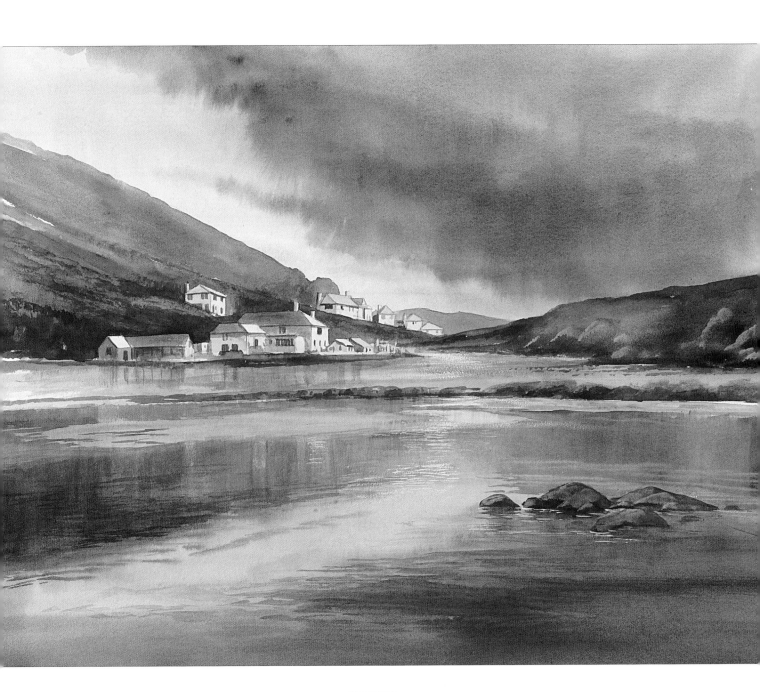

SEARCH PRESS

First published in Great Britain 2007

Search Press Limited
Wellwood, North Farm Road,
Tunbridge Wells, Kent TN2 3DR

Reprinted 2008 (twice), 2009

Text copyright © Terry Harrison 2007

Photographs by Roddy Paine Photographic Studios
Photographs and design copyright © Search Press Ltd. 2007

ISBN: 978-1-84448-198-9

The Publishers and author can accept no responsibility for
any consequences arising from the information, advice or
instructions given in this publication.

Suppliers
If you have any difficulty obtaining any of the materials and
equipment mentioned in this book, please contact

Terry Harrison at:

Telephone: +44 (0)1386 584840

Website: www.terryharrisonart.com

Publishers' note
All the step-by-step photographs in this book feature the
author, Terry Harrison, demonstrating how to paint with
watercolours. No models have been used.

Printed in Malaysia

To my daughters, Amy and Lucy.

*With thanks to everyone at Search Press in the UK, whose
continued faith in me has led to the publication of this, my
sixth book! Special thanks as always to my editor,
Sophie Kersey, who can always make sense of my muddled
thinking! My gratitude to Fiona Peart for her technical
support. Thanks also to all the lovely people I've had the
opportunity to meet during my visits to the US as a direct
result of the success the books have had there. In particular,
Barbara Klaus at the Decorative Book Club, Wanda Price at
Leisure Arts and Jay and Jane, the organisers of the
Painters Convention in Las Vegas.*

Cover
High Tide
38 x 54.5cm (15 x 21½in)
*The sky was painted wet into wet. The rays from the
sun were lifted out using kitchen towel. The rippled
detail in the sea was painted in wet on dry with the
small detail brush. The spray from the breaking
waves was achieved using masking fluid. The rock
formation in the foreground was created using the
credit card technique (see page 28).*

Page 1
Storm Closing In
68 x 50cm (26¾ x 19¾in)
*In this painting, storm clouds are moving in at the
end of the day, and the heavy rain clouds are sitting
in the dip of land. The last glimpse of the evening
light is shown in the centre of the painting, before
being squeezed out by the storm. The painting is set
at low tide, allowing me to illustrate the reflections
on the wet sand.*

Opposite
After the Storm
72 x 45cm (28¼ x 17¾)
*As the storm clouds move off into the sea, the
shoreline is lit by a strong burst of sunlight. The
figures on the wet sand add some interest – maybe
suggesting a story. The boats in the foreground break
up the strong horizontal lines.*

Contents

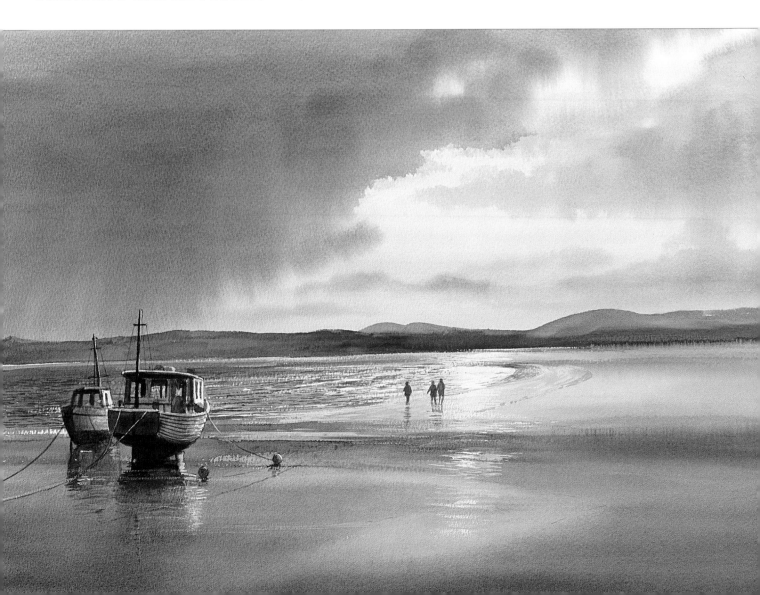

Introduction

I am not the type of artist that usually has his head in the clouds, but some days you just can't help yourself – I catch myself looking skywards and thinking, 'How would I paint that?'

Skies play an essential part in any landscape, and somehow combining an atmospheric sky with the drama of the sea can create the greatest free show on earth – never a repeat performance.

I don't know why I am attracted to painting seascapes, as I do live a fair way inland. However, this liking for the sea stems back to my childhood, when my ambition at one stage was to join the Navy. This was dashed after living in Germany for a couple of

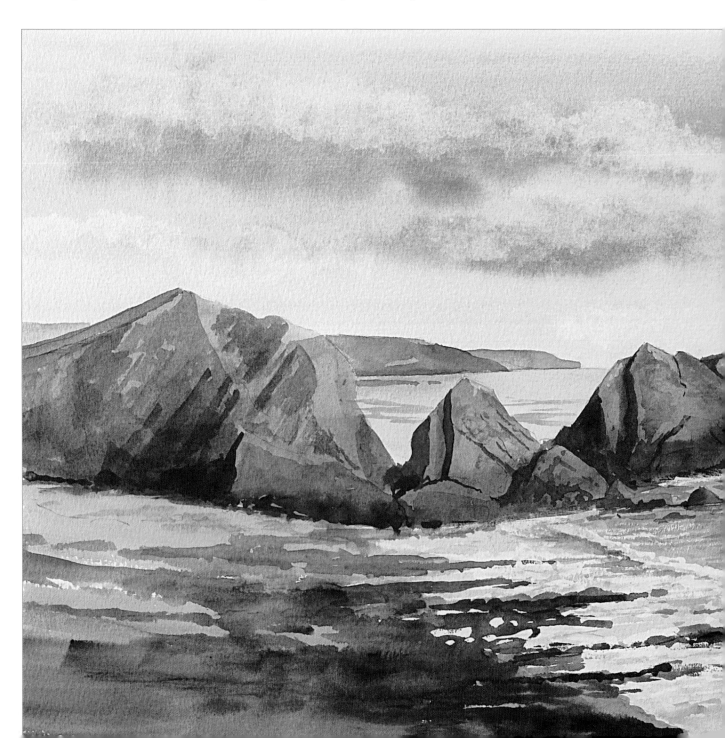

years and travelling on cross-channel ferries, which always seemed to result in terrible seasickness. To this day I still have the same problem with sea-going craft: for example on a recent holiday in the Mediterranean I was physically ill on a pedalo.

In this book the intention is to show you some basic painting skills to achieve certain elements of a seascape or skyscape. Hopefully by learning to master the basic elements of these subjects, you can then develop dramatic paintings of your own – creating restless, moody, powerful seas with crashing breakers and jagged rocks!

Terry Harrison

Rocky Headland
72 x 33cm (28½ x 13in)
This dramatic shoreline lends itself to a panoramic composition – long fingers of sharp teeth-like rocks stretching out into the incoming tide.

Materials

You will need a range of brushes and a selection of paints. I have used only one type of paper for the projects in this book, but you can use different weights and textures.

Paints

I always use artists' quality watercolours because they flow and mix better than the students' quality paints and give much better results. It is always advisable to buy the best paints you can afford. You can go a long way painting with only primary colours and a limited palette, but you may want to experiment with a wider range as you become more experienced.

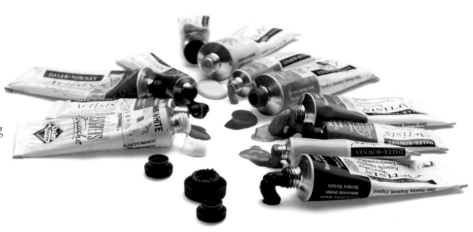

Brushes

Some artists adapt brushes to suit their personal requirements. I have gone a step further than this and designed my own range of brushes, specially made to make good results easily achievable, and these are used throughout this book. Pages 10–11 show how each of these brushes can be used to create a range of effects which you will find useful when painting seas and skies.

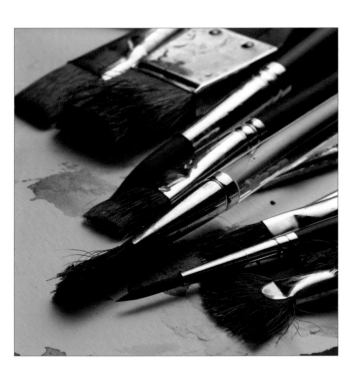

Paper

Watercolour paper comes in different weights and in three surfaces: smooth (called hot-pressed or HP), semi-smooth (called Not) and rough. I usually use 300gsm (140lb) rough paper, because the texture is useful for many of my techniques. You can use Not paper of the same weight if you need a smoother surface for detailed work.

I never bother to stretch paper before painting. If a painting cockles as it dries, turn it face down on a smooth, clean surface and wipe the back all over with a damp cloth. Place a drawing board over it and weigh it down. Leave it to dry overnight and the cockling will disappear.

Other materials

Hairdryer
This can be used to speed up the drying process if you are short of time.

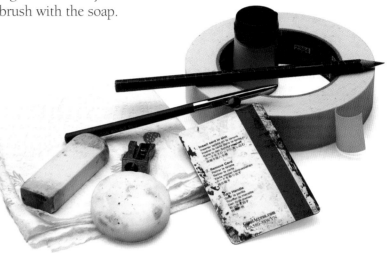

Masking fluid
This is applied to keep the paper white where you want to achieve effects such as ripples or foam in seascapes.

Soap
A bar of soap is useful to protect your brushes from masking fluid. Wet the brush and coat it in soap before dipping it in the masking fluid. When you have finished applying the masking fluid, it washes out of the brush with the soap.

Ruling pen
This can be used with masking fluid to create fine, straight lines.

Masking tape
I use this to tape paintings to my drawing board, and to create a straight horizon.

Pencil and sharpener
A 2B pencil is best for sketching and drawing, and you should always keep it sharp.

Eraser
A hard eraser is useful for correcting mistakes and removing masking fluid.

Credit card
Use an old plastic card for scraping out texture when painting rocks and cliffs.

Kitchen paper
This is used to lift out wet paint, for instance when painting clouds.

Easel
This is my ancient box easel. You can stand at it, as I do, or fold the legs away and use it on a table top. There is a slide-out shelf that holds your palette. This particular one collapsed shortly after we photographed it, after twenty years' service, but I have used the good bits, together with another easel, to rebuild it.

Bucket
Your brushes need to be rinsed regularly. This trusty bucket goes with me on the painting demonstration circuit so that I am never short of water.

My palette

I limit myself to a fairly small range of colours, and with the range shown here I find that I can paint virtually any scene I choose. This selection includes a warm and a cool blue, three ready-made greens, one yellow, a good range of earth colours, a good strong red, permanent rose (a useful pink that is difficult to mix from other colours), alizarin crimson which is ideal for creating purple shades, and shadow which is a ready-made transparent mix that is ideal for painting shadows.

ultramarine

cobalt blue

midnight green

country olive

sunlit green

cadmium yellow

raw sienna

burnt sienna

cadmium red

permanent rose

alizarin crimson

burnt umber

shadow

Useful mixes

The following colour mixes are useful for painting seas and skies
in various different conditions.

*Ultramarine and burnt umber make a good warm
grey which is excellent for painting storm clouds.*

*Cadmium yellow and permanent rose make a good
colour for a sky at sunset.*

*Ultramarine and midnight green make a good, deep
sea colour.*

*Cobalt blue and sunlit green mixed together make a
brighter sea colour for sunny conditions.*

Techniques

Brush techniques

You can create wonderfully realistic effects using just the range of brushes shown here.

Large detail

This brush is useful for painting rippled water. Varying the amount of pressure you apply can create different effects.

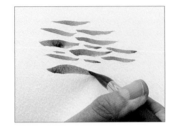

Flat brush

The 19mm (¾in) flat brush is useful for painting choppy water. Use a side to side motion with the tip of the brush.

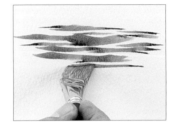

Medium detail

This is ideal for painting smaller details such as ripples on water.

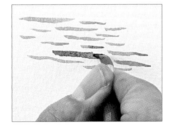

Small detail

This brush can be used to paint really small ripples on distant water.

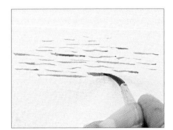

Half-rigger

The half-rigger has a really fine point but holds a lot of paint. The hair is long, though not as long as a rigger. As its name suggests, this brush is excellent for painting the rigging on boats. You can use a ruler to steady your hand to achieve a straight, even line by running the ferrule (the metal part) along the edge of the ruler.

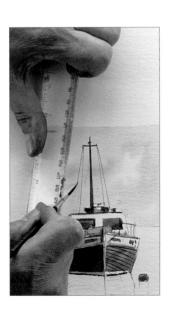

Golden leaf

This is a large wash brush which holds lots of paint and is ideal for painting washes and wet-in-wet skies. Use it to drop clouds into a wet wash.

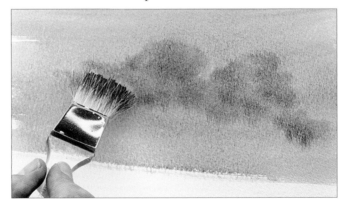

Foliage brush

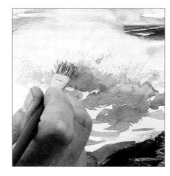

This smaller version of the golden leaf brush is good for painting foam bursts or adding texture to waves. You can also use it to paint shingle.

Fan stippler

This fan-shaped version of the foliage brush is ideal for painting sea spray.

Wizard

Twenty per cent of the hair in this brush is longer than the rest, which produces some interesting effects. To create reflections, paint a wash on first, then drag the brush down.

Fan gogh

This thick fan brush is excellent for painting streaks in waves, and also for sand and grasses.

Grand Emperor

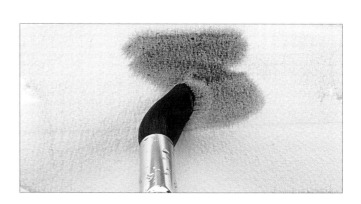

This large mop brush holds lots of paint and is good for washes and skies. It can be used for dropping a dark, stormy cloud into a wet sky wash.

Emperor extra large

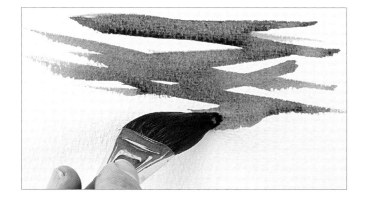

This large brush is useful for washes, but it also has a flat edge that is good for painting choppy water with a side-to-side motion.

Wet into wet

This involves putting wet paint on to a wet surface. The issue with this technique is how wet to make the initial wash. If there are puddles of water on the surface, it is too wet; the paper should just glisten. When adding paint to a wet surface, try not to overload the brush, or your paint will run away into the initial wash.

Tip
If your brush is overloaded, remove the excess moisture by dabbing it on to some kitchen paper.

Sky

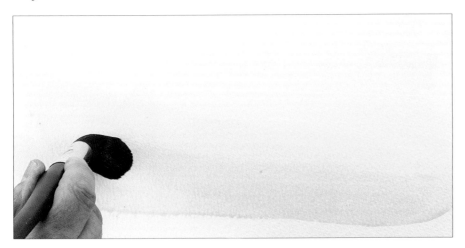

1. Wet the sky area with clean water using the Grand Emperor brush. Paint a thin wash of raw sienna on to the area near the horizon.

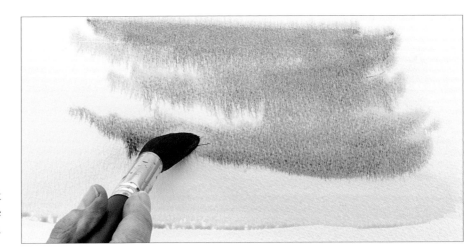

2. Mix ultramarine and burnt umber and streak it across the top of the sky.

Sea

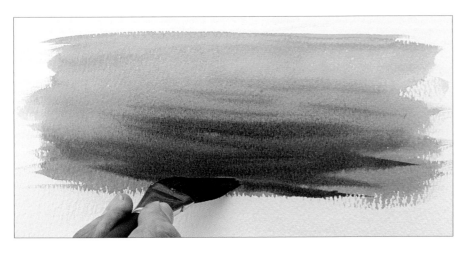

Use the Emperor extra large brush to apply a wash of cobalt blue. Then add streaks wet into wet using a stronger mix of ultramarine and midnight green.

Wet on dry

I know this is going to sound obvious, but this technique involves putting wet paint on to a dry surface. Skies are often painted wet into wet, but using a wet on dry technique gives you the option of adding detail in a more controlled way once your sky has dried. When painting seas, you can use this technique to add details such as ripples in sharp contrast with the background colour. If you did this wet into wet, the detail would dissolve into the background wash.

Sky

1. Use the Grand Emperor brush to apply a wash of raw sienna and allow it to dry.

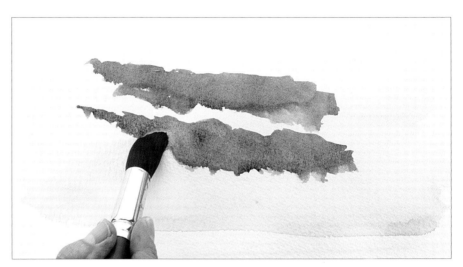

2. Paint on clouds using a mix of ultramarine and burnt umber. Painting wet on dry in this way creates harder edges.

Sea

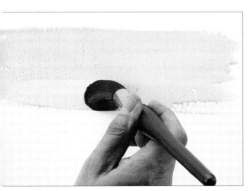

1. Paint on a wash using the Grand Emperor brush and allow it to dry.

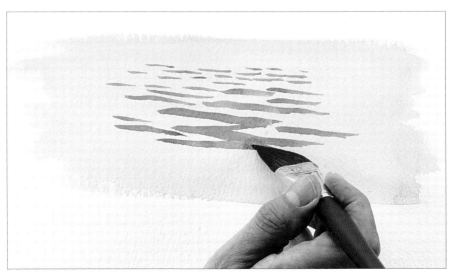

2. Paint on ripples using the tip of the Emperor extra large brush, moving it from side to side as shown.

Lifting out

This is a technique to remove surface paint using a sponge or kitchen paper while the paint is still wet.

Spray

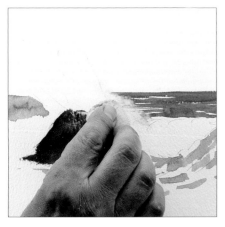

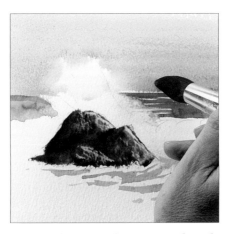

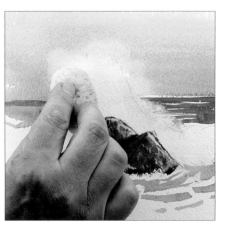

1. Use a slightly damp sponge to lift out the background sea painting to suggest spray from a wave hitting the rock.

2. Use the Grand Emperor brush to wash in the sky, leaving a gap for the spray where it will show against the sky.

3. While the sky wash is wet, use the sponge again to lift out the spray area. Allow the painting to dry.

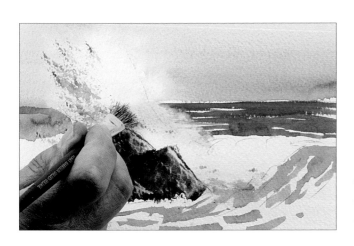

4. Use the foliage brush and a blue mix to paint in the texture of the spray.

Ripples

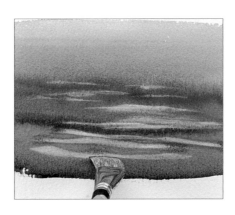

2. While the wash is wet, take the 19mm (¾in) flat brush, wet it and squeeze out the water. Lift out ripples with a side-to-side motion.

1. Paint on a wash for the water with the Grand Emperor brush.

Using masking fluid

Foam and ripples

1. Use an old brush and a flicking motion to mask out the foam, the ripples and the crests of distant waves.

2. Paint clean water on to the sky area using the Grand Emperor brush, then apply a wash of raw sienna.

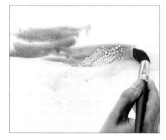

3. Mix ultramarine and burnt umber and paint in dark clouds wet into wet, going over the masking fluid.

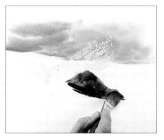

4. Use the 19mm (¾in) flat brush and a mix of ultramarine and burnt umber to paint the rock.

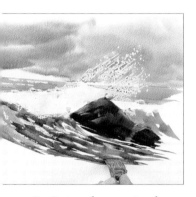

5. Paint the sea in the foreground using the 19mm (¾in) flat brush and a side-to-side motion as shown.

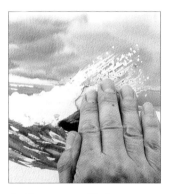

6. Remove all the masking fluid with clean, dry fingers.

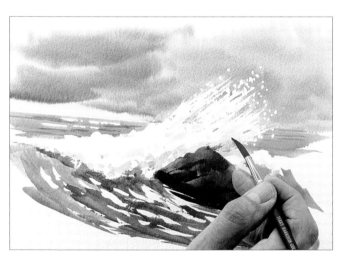

7. Use the medium detail brush and a thin mix of cobalt blue and midnight green to add detail to the foam.

Gulls

1. Use an old brush and masking fluid to mask out the gulls.

2. Use the Grand Emperor brush and ultramarine and burnt umber to paint the sky.

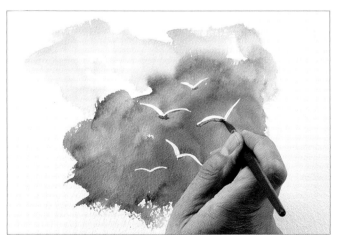

3. Rub off the masking fluid and add shading to the gulls using the medium detail brush.

Painting seas

When painting seas, the choice of brush can be important. A large mop brush can be used for large, flat areas, but a flat brush is useful for painting ripples and detail.

Calm water

1. Paint masking fluid on to the wave crests and the surf. Paint on clear water and then raw sienna for the beach using a 19mm (¾in) flat brush.

2. Paint the sea with ultramarine near the horizon, mixed with midnight green as you come forwards.

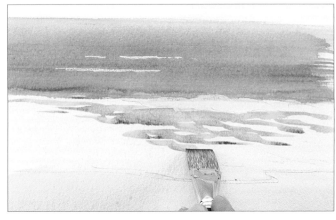

3. Use the tip of the flat brush and a side-to-side motion to paint ripples in the surf.

4. Rub off the masking fluid and use the small detail brush and ultramarine to paint distant ripples.

5. Add midnight green to the mix and paint the darker colour under the crests of the small waves. Add ripples.

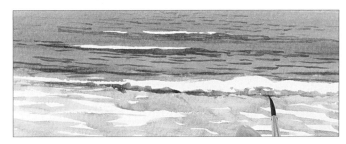

6. Use cobalt blue to paint shading under the crest of the foreground wave.

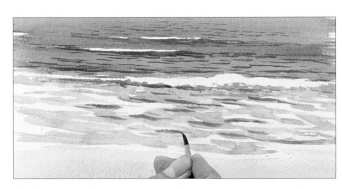

7. Use the ultramarine and midnight green mix to paint darker ripples in the foreground foam.

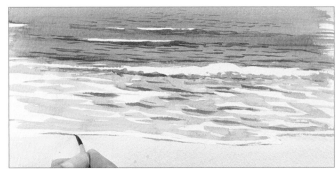

8. Still using the small detail brush, paint a broken line of the darker blue mix under the surf on the wet sand.

Choppy water

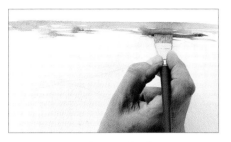

1. Paint ripples with the 19mm (¾in) flat brush and ultramarine.

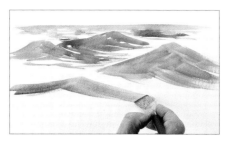

2. Using ultramarine and a touch of midnight green, paint in the peaks and troughs.

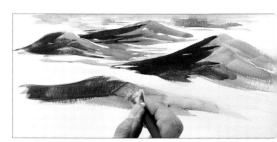

3. Add more midnight green to the mix and paint in the shaded sides of the waves.

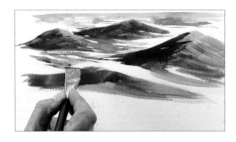

4. Use a pale wash of ultramarine and midnight green to paint ripples in the troughs between waves. This suggests a reflection of the sky.

Breaking waves

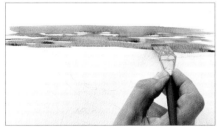

1. Take the 19mm (¾in) flat brush and paint ripples up to the top of the wave.

2. While the paint is wet, soften the top of the wave area using a damp sponge.

3. Paint the dark part of the wave, leaving some white streaks to imply foam.

4. While the paint is wet, soften the edge of the wave using the damp sponge. Make sure the sponge is clean each time you use it.

5. Using the large detail brush and a thin wash of cobalt blue, paint shading in the foam at the edge of the wave.

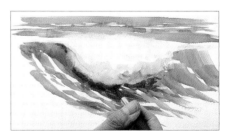

6. Allow the paint to dry. Mix ultramarine and midnight green to make a stronger blue and shade under the foam.

Crashing waves

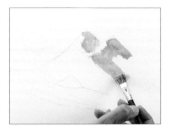

1. Use the foliage brush to paint a thick mix of raw sienna on to the rocks.

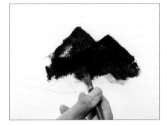

2. Paint a strong mix of ultramarine and burnt umber on top.

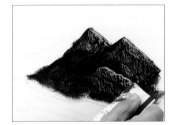

3. Use an old plastic card to scrape out rock shapes. This technique works best with rough surfaced paper. Allow to dry.

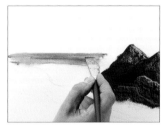

4. Use the 19mm (¾in) flat brush to paint clean water on the horizon area. Then paint on a mix of ultramarine and midnight green.

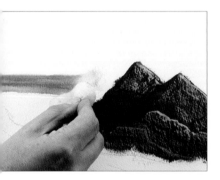

5. Lift out the area around the rock with a damp sponge to suggest spray. Allow to dry.

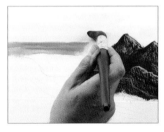

6. Use the Grand Emperor and raw sienna to paint the sky.

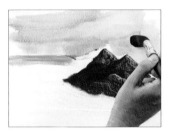

7. Paint dark clouds using a mix of burnt umber and ultramarine.

8. While the paint is wet, use the damp, clean sponge to lift out the spray around the rock.

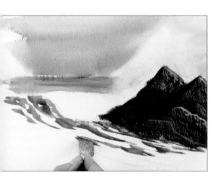

9. Use the 19mm (¾in) flat brush and a mix of ultramarine and midnight green to paint ripples at the base of the rocks, leaving white paper to suggest foam.

10. Use the fan gogh brush and the same mix to pull streaks over from the back of the wave forwards. Allow the paint to dry.

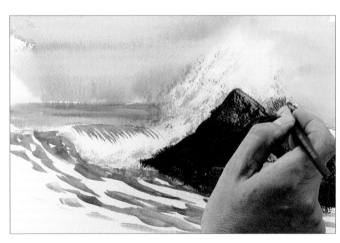

11. Take the foliage brush and use cobalt blue to add detail to the spray around the rock.

A shoreline

1. Mask the crests of the waves. Wet the sky area with clean water and use the Grand Emperor brush to paint raw sienna at the bottom of the sky.

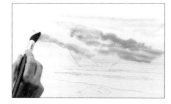

2. Mix ultramarine and burnt umber and paint on dark clouds, wet into wet.

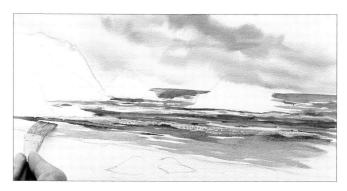

3. Use the 19mm (¾in) flat brush and ultramarine with midnight green to paint distant rippled water. Use a thinner wash of cobalt blue to paint rippled water in the foreground.

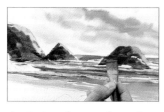

4. Paint the sunlit sides of the rocks with raw sienna. Then paint on ultramarine and burnt umber for the darker parts of the rocks.

5. Wet the beach area with clean water and paint a wash of raw sienna on to the lower part of the beach.

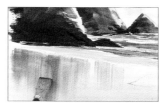

6. Pick up the ultramarine and burnt umber mix with the flat brush and drag the colour down vertically to create reflections.

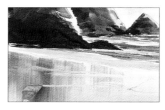

7. Clean the flat brush, squeeze water out of it and use it to lift out ripples in the water on the beach.

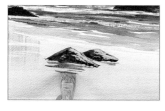

8. Use raw sienna, then burnt umber and ultramarine and the plastic card technique (see page 18) to paint rocks. Use the 19mm (¾in) flat brush and the dark rock mix to paint reflections.

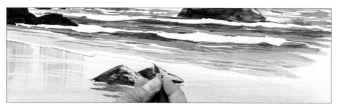

9. Use the medium detail brush and a mix of ultramarine and midnight green to paint shadow under the crests of the waves, and a broken line under the edge of the surf.

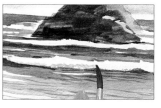

10. Use cobalt blue to apply light texture to the foam.

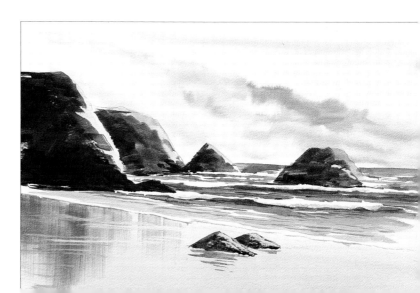

The finished painting.

Bands of colour

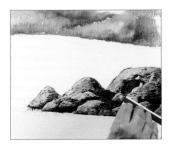

1. Paint the sky and background and then paint rocks using the plastic card technique shown on page 18.

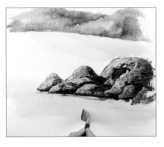

2. Use the 19mm (¾in) flat brush to paint a wash of raw sienna for the distant beach. Water down the mix towards the sea. Repeat for the foreground beach.

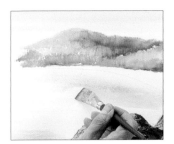

3. When the beach area is dry, wet the sea area with clean water and paint a wash of cobalt green deep in the background.

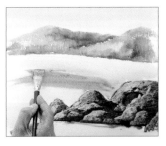

4. Paint with cobalt blue further forward, wet into wet.

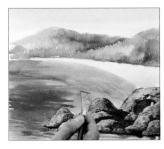

5. Paint a wash of cobalt blue and cobalt green over the foreground.

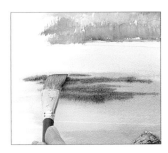

6. While the foreground is wet, paint ripples with a mid of ultramarine and midnight green.

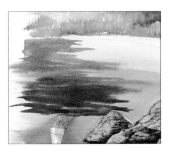

7. Add cobalt blue and cobalt green wet into wet with the flat part of the brush.

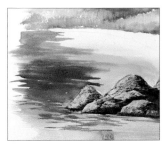

8. Use the ultramarine and midnight green mix to paint ripples in the foreground. Allow the painting to dry.

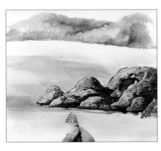

9. Wet the sea area and drag cobalt blue and cobalt green across it, following the direction of the shoreline. Allow to dry.

10. Use the small detail brush to add ripples with a mix of ultramarine and midnight green.

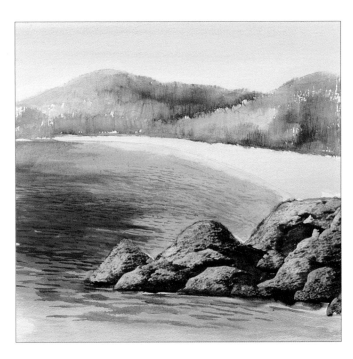

The finished painting.

The horizon

The most important thing about the sea horizon is that it must always be straight and never sloping. When applying the masking tape, put a pencil mark at one end of the horizon, then measure the same distance from the top of the paper at the other end and put a similar mark. Then you just need to join the dots!

1. Use the Grand Emperor and clean water to wet the sky area, then drop in a thin mix of ultramarine. Leave to dry.

2. Apply masking tape to the bottom of the dried sky area, with the lower edge where you want the horizon to be.

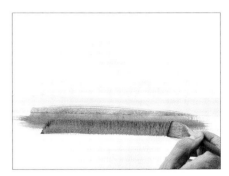

3. Use the 19mm (¾in) flat brush to paint on a mix of ultramarine and midnight green for the sea. Go over the lower edge only of the masking tape. Leave to dry.

4. Make a stronger, darker mix of the same colours and paint from side to side with the flat brush to create ripples.

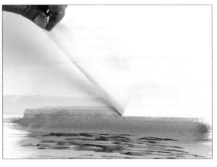

5. Remove the masking tape to reveal the straight horizon. Always pull away from the horizon line.

Tip
You can buy low-tack masking tape, which reduces the risk of tearing the surface of the paper.

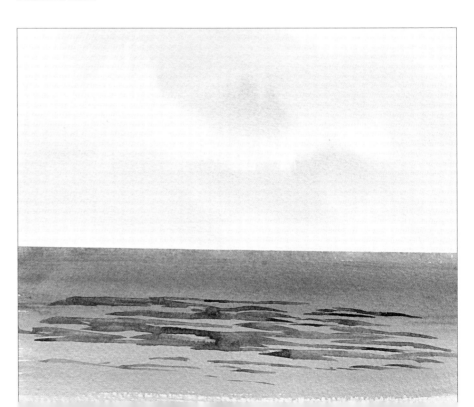

The finished horizon.

Painting skies

Many artists before me have said that to improve your skies you should paint a sky a day – I heartily concur but let's face it – who's going to do that? However, the sky will almost always play a role in any landscape or seascape – this can be a large dramatic role, or a small supporting part.

A clear sky

Most artists look for clouds or something to inspire you to get your brushes out – but sometimes the sky is just clear, so it is worth knowing how to paint a clear blue sky.

1. Wet the sky area first with clean water and the golden leaf brush. Load the brush evenly with a wash of ultramarine. Start at the top and paint from side to side.

2. As you continue down the paper, the sky gets lighter as there is less colour on the brush. The wet into wet technique disperses any streaks.

A cloudy sky

This gives you something more to get your teeth into, but sometimes if the sky is too interesting, it can detract from the rest of your picture. This is a simple cloudy sky that would look good in most paintings.

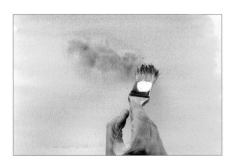

1. Wet the area first with clean water. Paint on a wash of ultramarine with the golden leaf brush. Mix ultramarine and burnt umber to make grey, and paint clouds into the wet background.

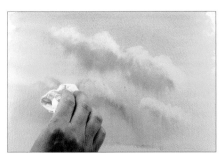

2. Use a pad of kitchen paper to lift the colour out of the tops of the clouds.

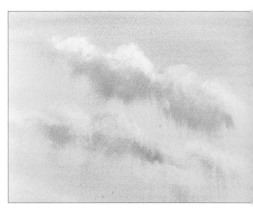

The effects will continue to develop as the sky dries.

A stormy sky

This can create atmosphere in a scene, which could be essential to the painting – for example when creating a storm at sea, or a weather front moving across the moorlands.

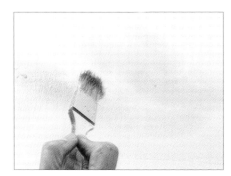

1. Paint on clean water first. Then paint on patches of raw sienna with the golden leaf brush.

2. Paint dark clouds wet into wet using a mix of ultramarine and burnt umber.

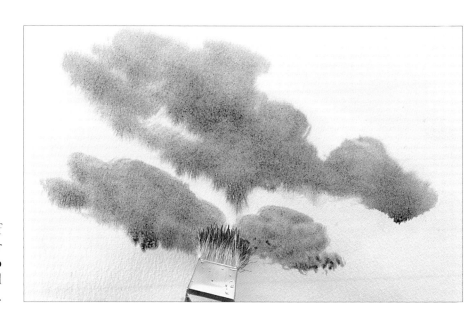

3. Use a darker mix of ultramarine, burnt umber and a touch of crimson to paint darker clouds, still working wet into wet.

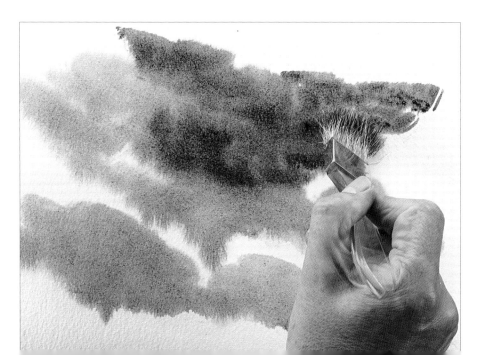

4. Add more dark clouds to finish the sky.

Another cloudy sky

This version of a cloudy sky also uses wet into wet and lifting out techniques, but this time the shapes of the clouds are suggested in the initial wash. This is a more controlled method of painting clouds, giving greater definition to your sky.

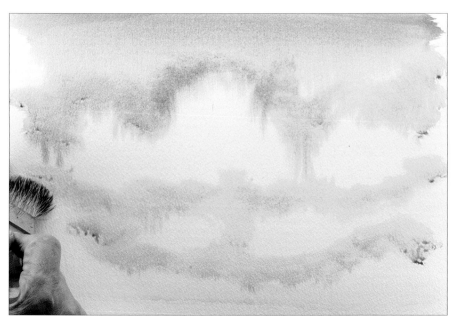

2. Tidy up the edges of the clouds by lifting out colour using kitchen paper. Allow the painting to dry.

1. Wet the sky area with clean water. Take the golden leaf brush and a wash of ultramarine, and paint a sky, leaving white spaces for clouds.

3. Wet the whole sky area again with clean water. Pick up a mix of ultramarine and burnt umber and touch in shadows at the bottom of the clouds.

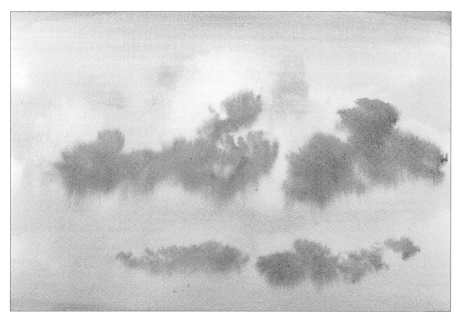

4. Continue adding shadows until you are happy with the effect.

A sunset

Sunsets are very popular and because no two are ever the same. This provides endless scope for producing dramatic, atmospheric skies.

1. Wet the sky area with clean water. Use the golden leaf brush to apply cadmium yellow across the middle of the sky.

2. Paint a band of cadmium red wet into wet, under the yellow.

3. Above the band of yellow, paint alizarin crimson wet into wet, fading it into the yellow.

4. Still working wet into wet, paint cobalt blue at the top of the sky, running down into the alizarin crimson. In this way you avoid accidentally creating green by mixing the blue with the yellow.

5. Working quickly, wet into wet, drop in shadow colour to create dark clouds.

6. Create a v-shaped cloud formation, making sure that there are smaller clouds lower down the sky, as this helps to create the illusion of distance.

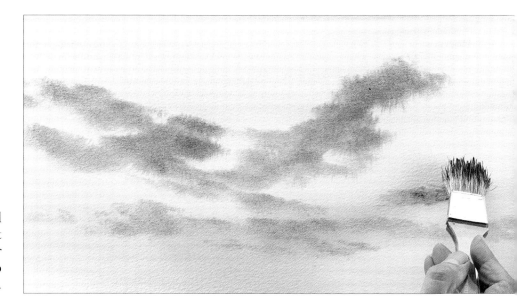

Painting reflections

The technique I am going to show you in this step-by-step demonstration is a fairly simple process, but produces more than a complete mirror image. It is easy to achieve, but very effective.

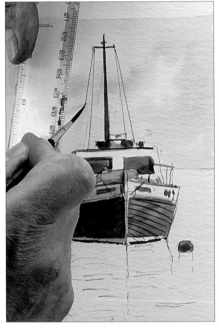

1. Paint the boat and the sky first. Paint the rigging using a half-rigger brush and a ruler as shown to achieve thin, straight lines.

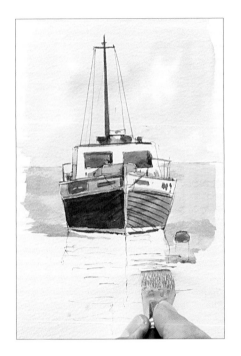

2. Take the 19mm (¾in) flat brush and paint the water with a light wash of cobalt blue. Paint ripples and leave white paper to suggest reflections of the white boat.

3. Drag down the colour at the bottom of the water area.

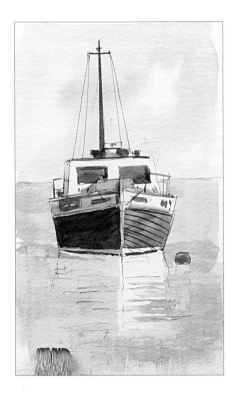

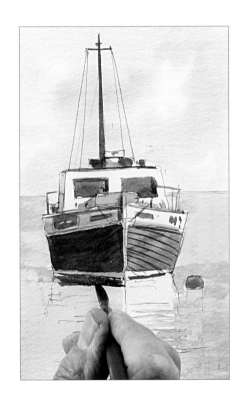

4. Paint the reflection of the dark side of the boat using a mix of ultramarine and burnt umber and the medium detail brush. The reflection should be quite solid close to the boat.

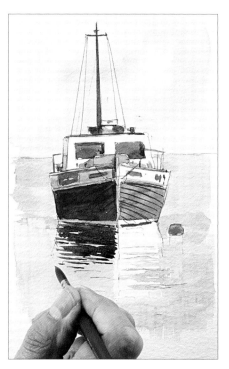

5. Further down, paint ripples as the reflection becomes less solid.

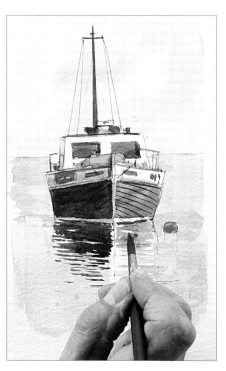

6. Use a lighter mix of cobalt blue to paint the reflection of the right side of the boat in the same way.

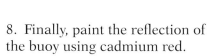

7. Paint looser, light blue ripples further down the water.

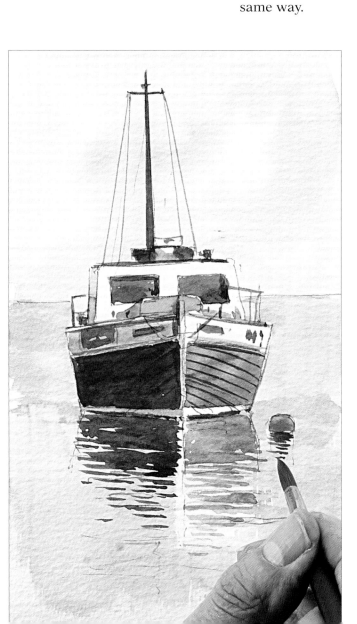

8. Finally, paint the reflection of the buoy using cadmium red.

27

Other elements

When painting a seascape, there is much more to the painting than just the water. Here I show you a small selection of useful techniques that will help you achieve a realistic seascape.

Rocks

This is a technique that I have recently developed. It uses a plastic card such as a credit card. The colours used in this example are quite warm, but if you want to achieve a cooler effect, use colours such as blue and grey.

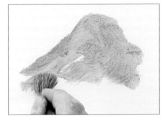

1. Paint the rock shape using a thick mix of raw sienna and the stiff-haired foliage brush.

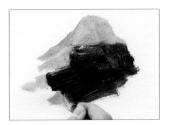

2. Paint a dry mix of burnt umber on top.

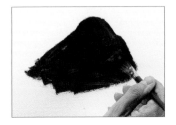

3. Mix ultramarine and burnt umber and paint over the whole rock.

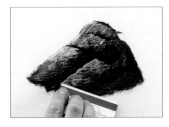

4. Use a plastic card to scrape the surface of the rock, leaving gaps as shown to suggest crevices.

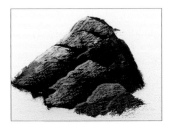

The finished rock.

Tip
Use hardly any water with the paint for this technique. It will not work with wet paint mixes.

Shingle

To achieve successful shingle, it is essential to create a textured effect. This is a simple technique, just using the foliage brush.

1. Paint on a thin wash of raw sienna using the foliage brush and allow it to dry.

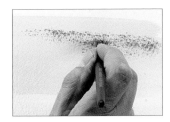

2. Use the foliage brush to stipple on burnt umber to suggest the texture of the shingle.

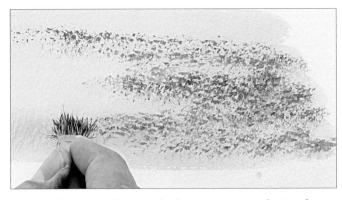

3. Mix burnt umber and ultramarine and stipple this darker mix on top.

Sand dunes

The introduction of sand dunes to a painting can create interest in the foreground, which will lead you into the scene.

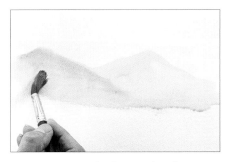

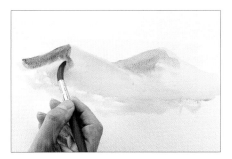

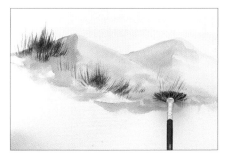

1. Paint on a light wash of raw sienna with the large detail brush, then paint in the dunes with a stronger mix.

2. Paint the shaded sides of the dunes with shadow colour, wet into wet. Allow to dry.

3. Use the fan gogh brush and midnight green to flick up grasses in the dunes.

Cliffs

Again, this uses the plastic card technique to create the different faces of the cliff.

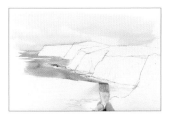

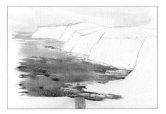

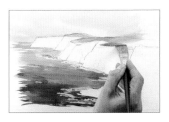

1. Mask the surf at the water's edge using masking fluid. Paint clean water in the sky area, then apply an ultramarine wash.

2. Use the 19mm (¾in) flat brush and ultramarine with midnight green to paint the sea with a side to side motion.

3. Add more midnight green towards the foreground.

4. Paint a thin mix of country olive and ultramarine on the headland, making the mix stronger in the foreground.

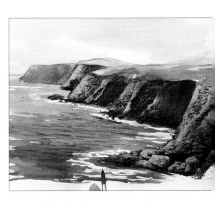

5. Paint thick raw sienna on the cliffs, then an ultramarine and burnt umber mix. Scrape off with a plastic card to create rocky texture.

6. Remove the masking fluid from the surf at the water's edge using a clean finger.

7. Add ripples using the medium detail brush and a strong mix of ultramarine and midnight green. The ripples should be bolder in the foreground to create perspective.

8. Add a light touch of cobalt blue in the surf to suggest shading.

A lighthouse

This step-by-step demonstration illustrates how versatile masking fluid can be. With little effort, you can create a dramatic transformation in your painting.

1. Use masking fluid to mask the lighthouse tower and the water where it meets the rock. Paint the sky with clean water, then raw sienna with the Grand Emperor brush.

2. Mix burnt umber and ultramarine to paint clouds. Go over the masked lighthouse.

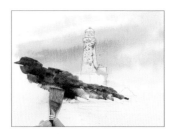

3. Use the 19mm (¾in) flat brush and a mix of ultramarine and burnt umber to paint the rock formation.

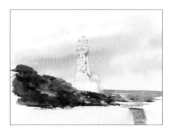

4. Paint the sea with the same brush and ultramarine and midnight green. Use a side to side motion to create ripples.

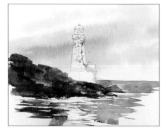

5. Use a greener mix towards the foreground. Allow to dry.

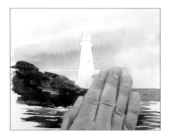

6. Remove the masking fluid by rubbing with clean fingers.

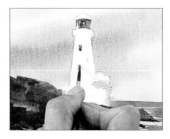

7. Take the small detail brush and a bluey mix of ultramarine and burnt umber and add details to the lighthouse.

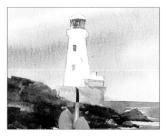

8. Shadow the right-hand side of the lighthouse base using a mix of raw sienna and cobalt blue. Then add raw sienna to the left-hand side and texture it using the shadow mix.

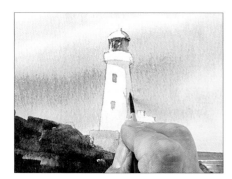

9. Add shadow to the right-hand side of the lighthouse using cobalt blue.

10. Add cobalt blue ripples in the water to finish the painting.

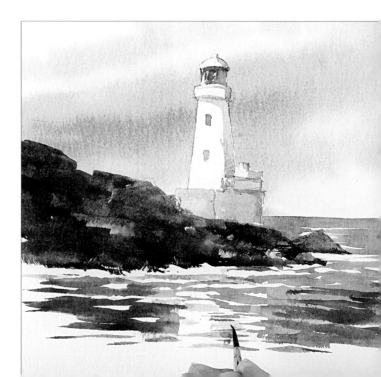

Boats

The key to painting boats successfully is to be very precise. They are not difficult, but you do need to draw what you see – not what you think you see! The example shown here relies heavily on the effect of the dark, shady sides of the boats.

1. Use the medium detail brush and raw sienna to paint the right-hand side of the boat on the right. Then add detail using a thin mix of burnt umber.

2. Paint the reflection in the same way, with raw sienna and then burnt umber.

3. Paint the dark part of the boat and its reflection using ultramarine and burnt umber.

4. Next paint the shadow inside the boat.

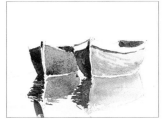

5. Paint the other boat and its reflection with burnt sienna and burnt umber, then burnt umber and ultramarine for the dark side.

6. Use the large detail brush and a very thin mix of ultramarine to paint the background sea up to the boats.

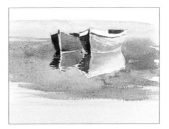

7. Paint a stronger mix coming further forwards and allow the painting to dry.

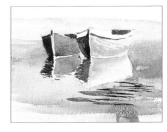

8. Use the 19mm (¾in) flat brush and midnight green with ultramarine to paint ripples.

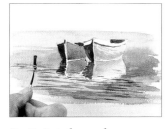

9. Paint the pole sticking out of the water using the small detail brush with burnt umber and ultramarine.

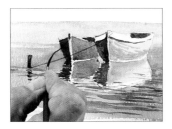

10. Change to the half-rigger brush to paint the ropes.

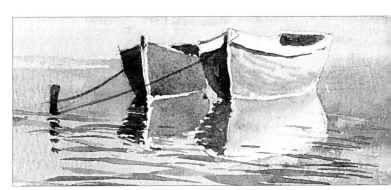

The finished boats.

Crashing Waves

This shoreline drama of crashing waves on rugged rocks is played out most days – some days with more gusto than others. This demonstration captures that moment when the wave smashes into the solid, immovable rocks on the foreshore, pushing the spray high into the sky.

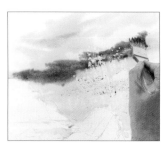

1. Use masking fluid to mask the foam burst and the rivulets of water running off rocks.

2. Wet the sky area with the golden leaf brush and clean water, then apply a wash of raw sienna.

3. Paint ultramarine in sweeping, diagonal strokes across the sky, going off the top of the painting.

4. Paint clouds using ultramarine and burnt umber, sweeping across the masked foam burst.

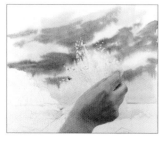

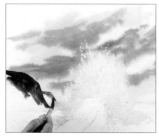

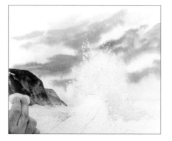

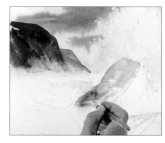

5. Use a damp sponge to remove paint around the foam burst. Allow the painting to dry.

6. Paint in the headland with the large detail brush and ultramarine with burnt umber.

7. Use a clean, damp sponge to lift out paint at the base of the headland, suggesting a sea mist.

8. Use the fan stippler and thick raw sienna to paint the sunlit sides of the rocks.

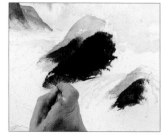

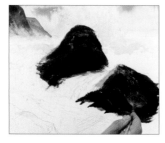

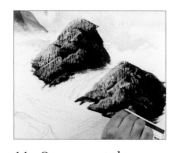

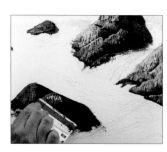

9. Paint on burnt umber on top, then ultramarine on top of that.

10. Paint a mix of ultramarine and burnt umber on top.

11. Scrape out the shape of the rocks using a plastic card.

12. Mix ultramarine and burnt umber to paint the other rocks and scrape out the texture in the same way.

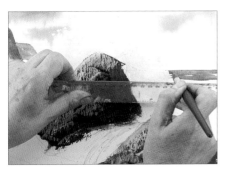

13. Take the large detail brush and paint the sea with side to side strokes to suggest ripples. Use a ruler to help you paint a straight horizon.

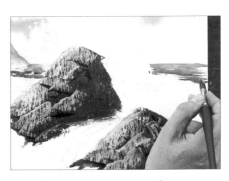

14. Continue painting the sea with ultramarine and midnight green as you come forwards.

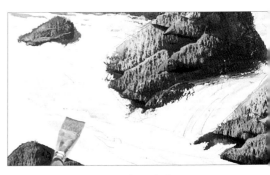

15. Use the 19mm (¾in) flat brush and a thin wash of sunlit green to paint ripples.

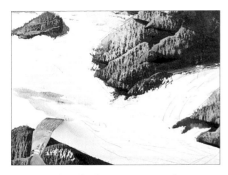

16. Add cobalt green ripples in the same way.

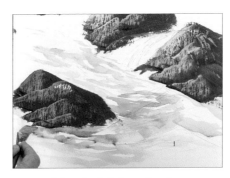

17. Add cobalt blue ripples towards the foreground.

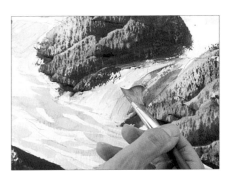

18. Add cobalt blue and burnt umber over the masking fluid where water flows between the rocks.

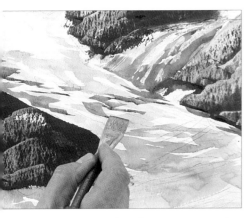

19. Paint midnight green streaks across the waves.

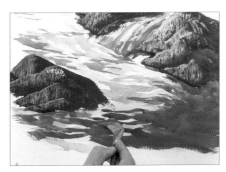

20. Paint larger ripples in the foreground with a mix of midnight green and ultramarine.

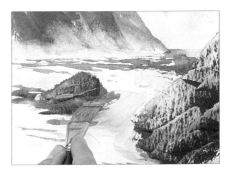

21. Paint round the distant rock with the same colour mix.

22. Paint very dark ripples of midnight green and ultramarine in the foreground.

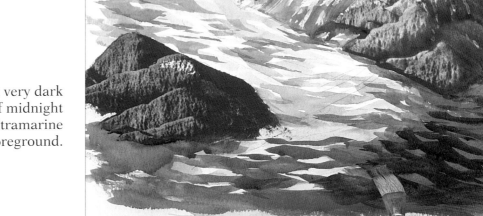

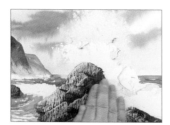

23. Rub off the masking fluid with clean fingers.

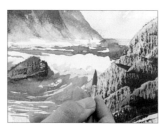

24. Use the medium detail brush and a thin mix of cobalt blue to paint shading on the foam.

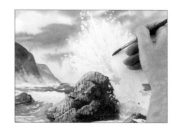

25. Using the same mix, push the brush in the direction of the foam burst.

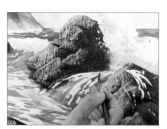

26. Shade the rivulets of water between the rocks in the same way.

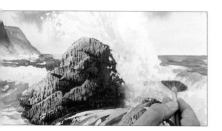

27. Use the fan gogh brush and a mix of midnight green and ultramarine to paint the crest of the wave behind the foam burst.

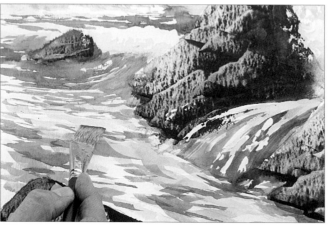

28. Take the 19mm (¾in) flat brush and paint a cadmium yellow and sunlit green mix over the water on the left of the rocks.

29. Paint over this mix wet into wet with a wash of cobalt green.

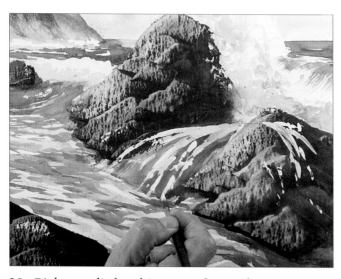

30. Pick up a little white gouache on the medium detail brush and tidy up the rivulets between the rocks.

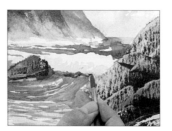

31. Mix cobalt blue and midnight green and darken under the breaking waves.

32. Use the medium detail brush and a little white gouache to add detail to the spray in the distance.

Opposite

The finished painting. The techniques used here are very important to the success of the painting. The detail of the rocks relies heavily on the plastic card technique and the texture of the paper. The use of masking fluid helps to preserve the light of the sea spray against the dark, cloudy sky.

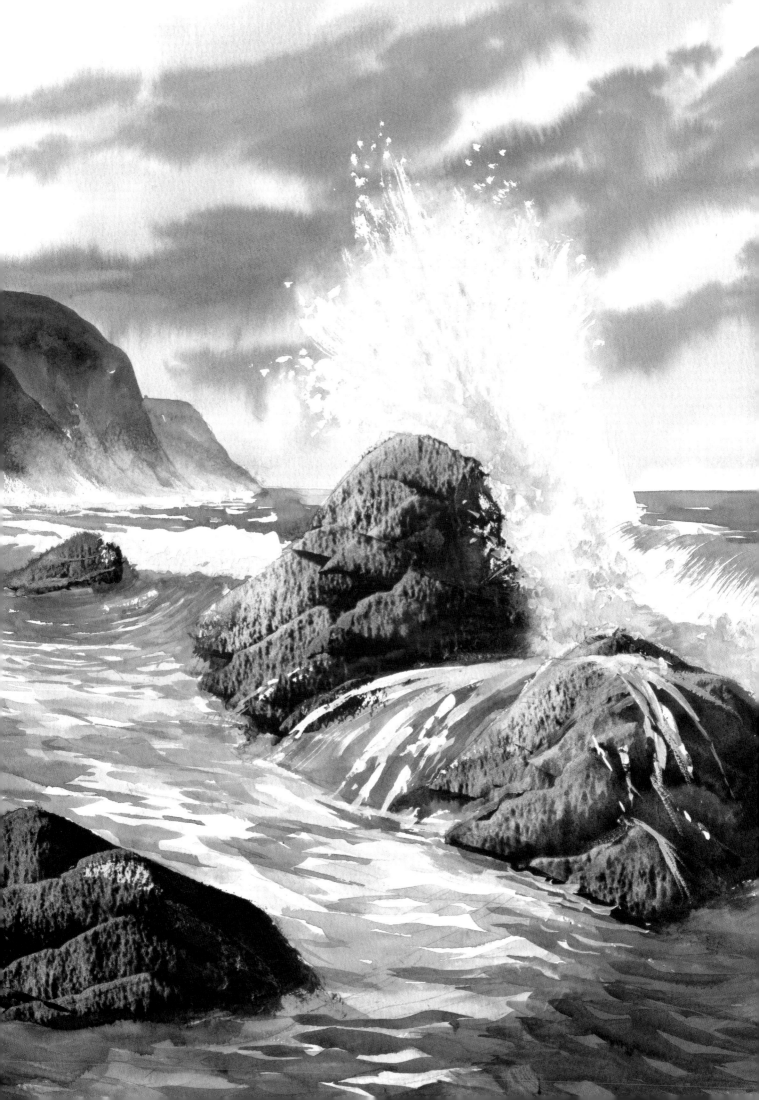

Coastal Footpath

This demonstration uses the foreground to lead you into the painting, and to add colour and interest to the picture. The path takes you round into the bay, and the sweep of the shoreline brings you out to the headland, then the clouds lead you back in the opposite direction, creating a dramatic, zigzagging composition.

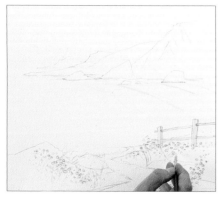

1. Use masking fluid to mask the flower heads, the fence and the edges of the water.

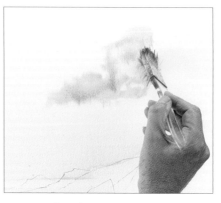

2. Wet the sky area using clean water and the golden leaf brush. Paint cloud shapes with ultramarine.

3. Mix ultramarine and burnt umber and paint dark shadows under the white of the clouds, wet into wet.

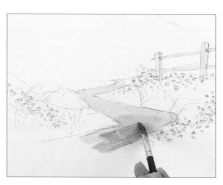

4. Take the wizard brush and paint the footpath with raw sienna. Make the colour pale towards the sea and stronger in the foreground.

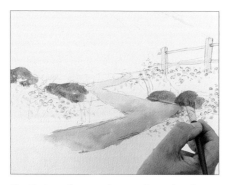

5. Paint the rocks with a thick mix of raw sienna.

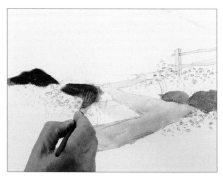

6. Paint a thick mix of burnt umber and ultramarine on top of the raw sienna.

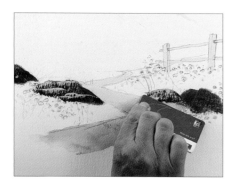

7. Scrape out the texture of the rocks using a plastic card.

8. Use the fan gogh brush and sunlit green paint to flick up grasses.

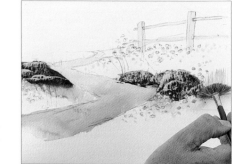

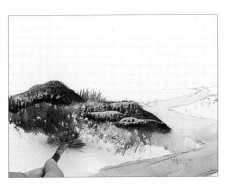

9. Add burnt sienna to the grassy area, wet into wet.

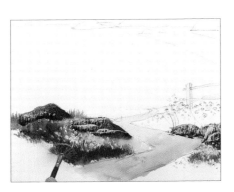

10. Still working wet into wet, paint more grasses using country olive.

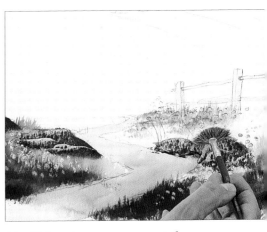

11. Paint the area nearest the fence using country olive and raw sienna. Allow to dry.

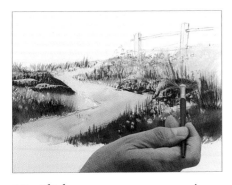

12. Flick up more grasses using the fan gogh brush, painting wet on dry on the yellowish area in front of the fence.

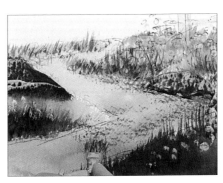

13. Using the foliage brush, stipple a mix of raw sienna and burnt umber on to the footpath.

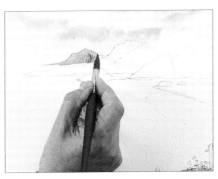

14. Use the large detail brush and ultramarine with a touch of burnt umber to paint the distant headland.

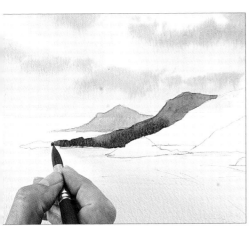

15. Paint the next hill coming forwards with a stronger mix.

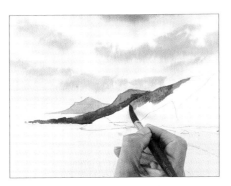

16. Mix raw sienna with ultramarine to make a warmer mix and paint the next hill coming forwards.

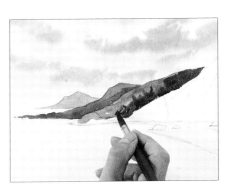

17. Drop in a darker mix of ultramarine and burnt umber wet into wet.

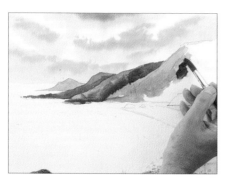 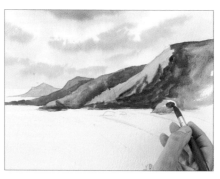 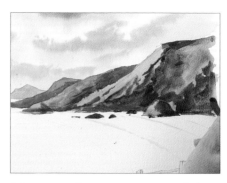

18. Paint the next hill forwards with raw sienna, then drop in ultramarine and burnt umber wet into wet to suggest crevices.

19. Paint the smaller rock on the beach in the same way.

20. Paint the nearest part of the rocks with ultramarine and burnt umber and leave the painting to dry.

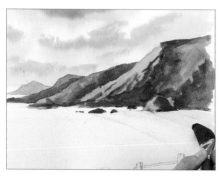 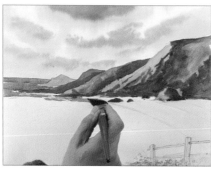 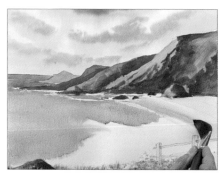

21. Wet the beach and sea area with the Emperor extra large brush and clean water. Paint on a thin wash of raw sienna for sand.

22. Use the same brush and ultramarine and midnight green to begin painting the sea.

23. Add more ultramarine to the mix as you come further forwards, painting wet into wet.

24. Drop in a stronger, greener mix wet into wet.

25. Paint lines of the greener mix to suggest waves coming in to the shore.

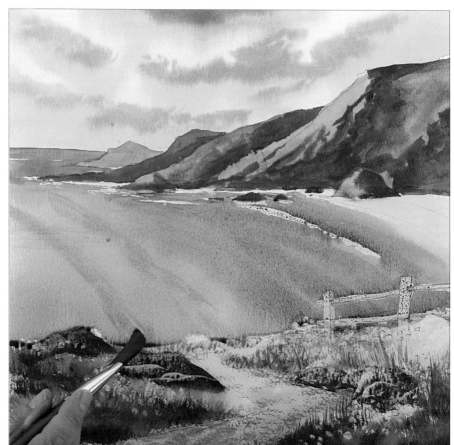

26. Take the large detail brush and darken the furthest headland with a mix of burnt umber and ultramarine. Leave it to dry.

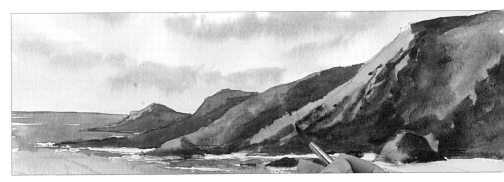

27. Using the medium detail brush and the colour shadow, add detail and texture to the headland.

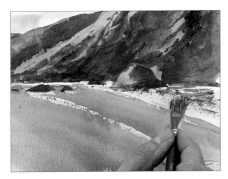

28. Change to the foliage brush and pick up shadow to paint texture on the beach.

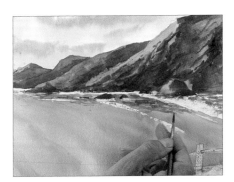

29. Use the small detail brush and a mix of ultramarine and midnight green to paint ripples near the shore.

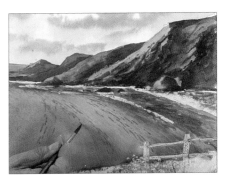

30. Continue painting ripples further out to sea, following the line of waves coming in to shore.

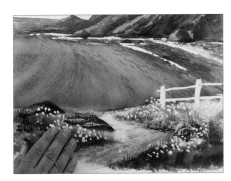

31. Rub off all the masking fluid with clean fingers.

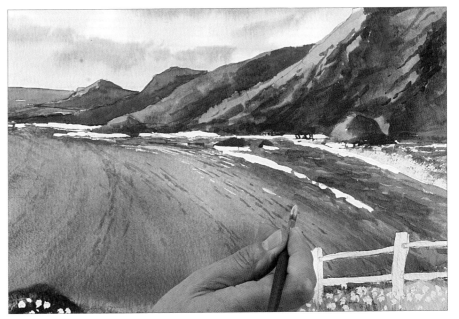

32. Mix white gouache with a touch of cobalt blue and use the medium detail brush to add highlights to ripples coming in to shore.

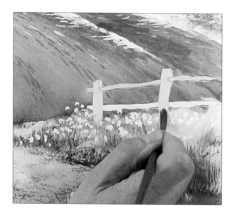 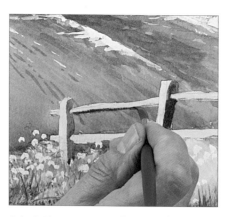 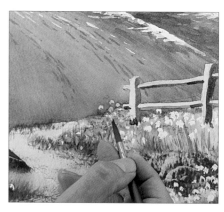

33. Paint the fence with the medium detail brush and a pale wash of raw sienna and sunlit green. Allow the painting to dry.

34. Mix country olive and burnt umber and add shading to the fence.

35. Take the small detail brush and paint a thin mix of permanent rose on the flowers.

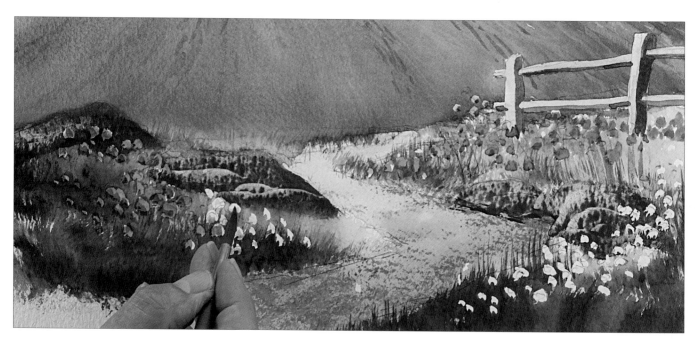

36. Paint the flowers on the left in the same way. Then paint a stronger mix of permanent rose wet into wet. Vary the strength of the pink to create variety. Leave some flowers white, and use cobalt blue to shade others.

Opposite
The finished painting. I used a half-rigger brush to do some last minute tidying, and to paint grasses in the foreground.

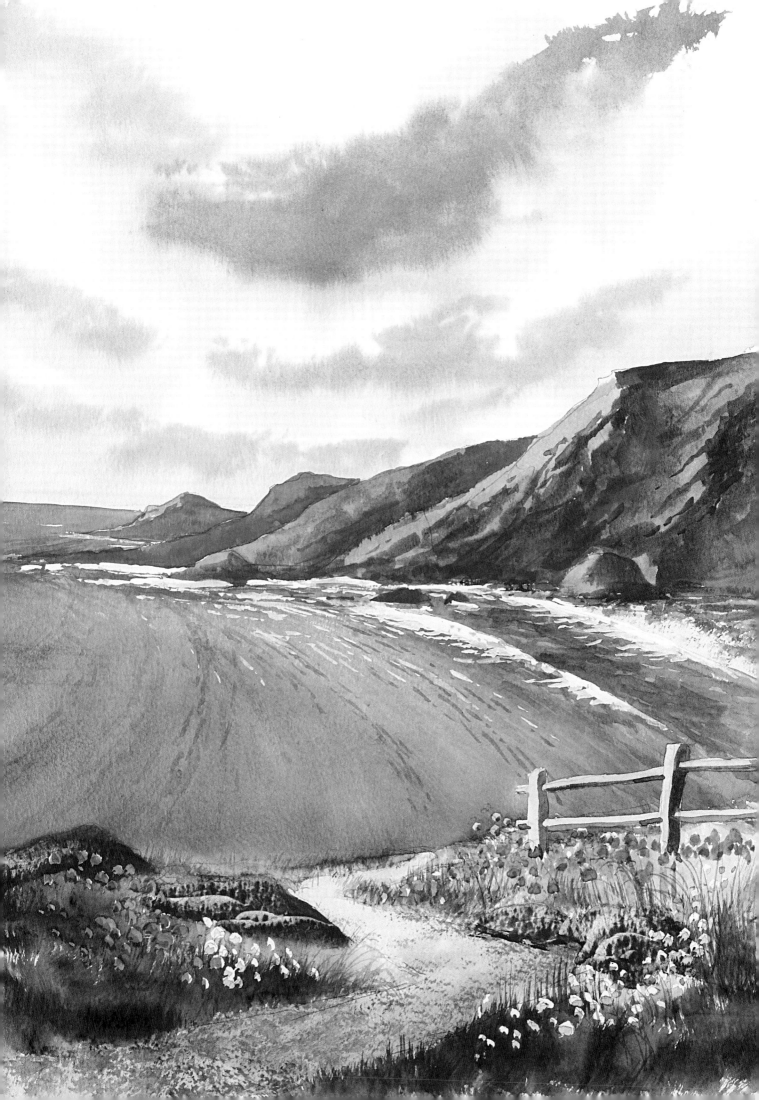

Sunset on the Sea

Watching a sunset is one of life's pleasures, and it only gets better when it is setting over the sea. Capturing that moment in watercolour can only enhance that feeling. This demonstration combines a variety of techniques that you will have used earlier in the book, for example wet into wet, lifting out, using masking fluid and the plastic card technique.

1. Draw the scene and use masking fluid and an old brush to mask off the sunlit ripples in the centre of the painting.

2. Wet the sky area with the golden leaf brush and clean water. Paint a wash of cadmium yellow across the whole sky.

3. Working quickly wet into wet, drop in a weak mix of cadmium red from the top of the sky.

4. Then paint a wash of cadmium red and alizarin crimson at the bottom.

5. Lift out the area where the sun shines through using a piece of kitchen paper.

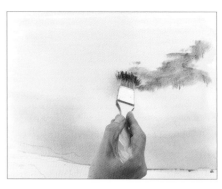

6. Still working wet into wet, paint cloud shapes using the colour shadow.

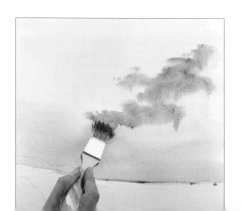

7. The clouds will naturally have a harder-edged look where they go over the lifted out area.

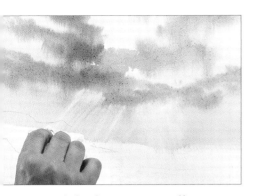

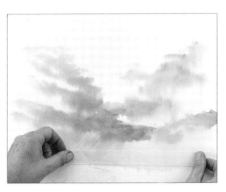

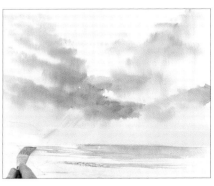

8. While the paint is still wet, take a piece of kitchen paper and lift out streaks to suggest sunlight streaming through the clouds.

9. Allow the painting to dry, then place masking tape above the line where you want the horizon to be.

10. Use the 19mm (¾in) flat brush and a mix of cobalt blue and alizarin crimson to paint the sea up to the masking tape. Sweep from side to side to create the effect of ripples.

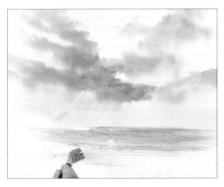

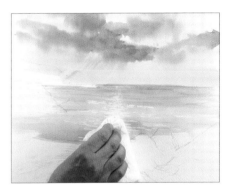

11. Paint a mix of cadmium red and cadmium yellow over the top of the blue.

12. Paint with the same orangey mix over the masked area and the foreground.

13. Lift out colour from the centre of the painting, below the sun, using kitchen paper.

14. Use the medium detail brush to paint cadmium yellow on to the foreground to strengthen the colour there.

15. Sweep shadow colour across the horizon, towards the centre.

16. Sweep in more shadow colour from the left.

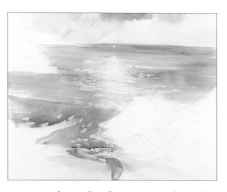

17. Darken the foreground with more shadow. Allow the painting to dry.

18. Remove the masking tape to reveal the horizon line.

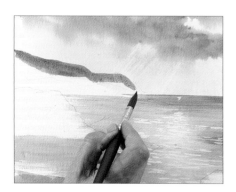

19. Use the large detail brush and a mix of burnt sienna and shadow for the distant headland.

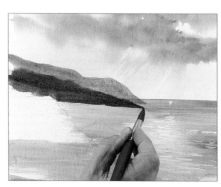

20. Mix burnt umber and shadow to darken the headland at the base.

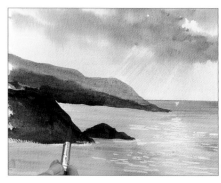

21. Use a mix of ultramarine and burnt umber for the land in the middle distance.

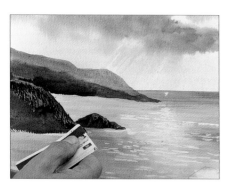

22. Scrape out the sunlit side of the land in the middle distance using a plastic card to create texture.

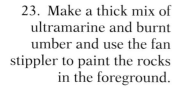

23. Make a thick mix of ultramarine and burnt umber and use the fan stippler to paint the rocks in the foreground.

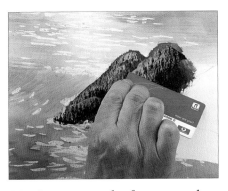

24. Scrape out the foreground rocks in the same way.

25. Add more dark rocks using burnt umber, ultramarine and the fan stippler, and scrape out texture and crevices as shown.

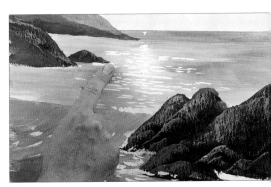

26. Rub off the masking fluid with a clean finger.

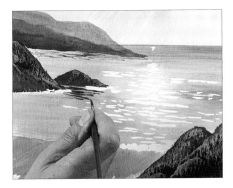

27. Change to the small detail brush and use shadow colour to paint rippled reflections of the rocks.

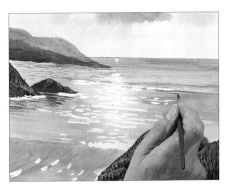

28. Continue painting ripples and shadows under the white crests of waves.

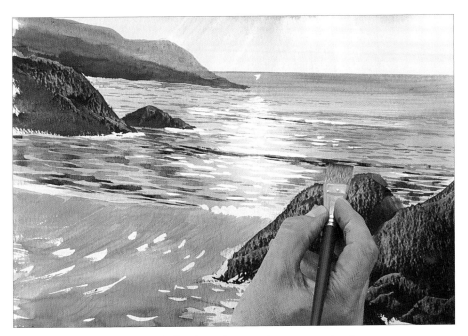

29. Use the 19mm (¾in) flat brush to paint more ripples.

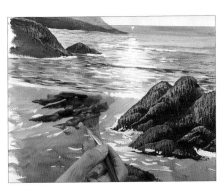

30. Darken the beach using the 19mm (¾in) brush and a mix of shadow and burnt sienna.

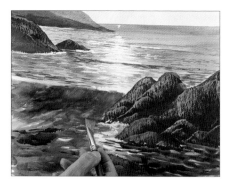

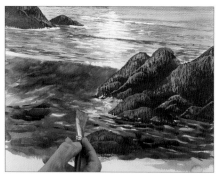

31. Mix cadmium red and cadmium yellow and paint over the dark colour of the beach, wet on dry.

32. Add more of the same orange mix in the white ripples under the rocks.

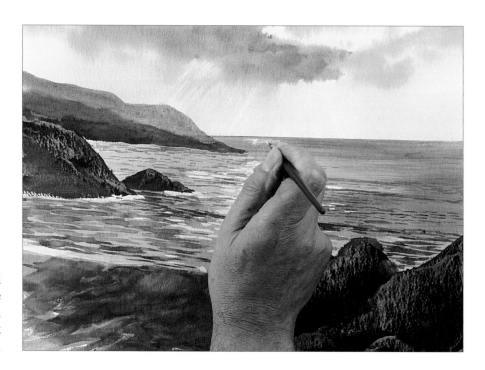

33. Add a little cadmium red and cadmium yellow to white gouache and use the small detail brush to paint the strip of light near the horizon.

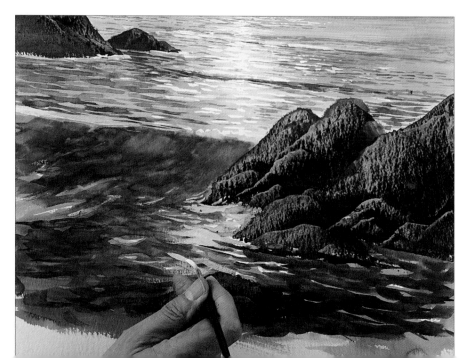

34. Use the same gouache and orange mix to paint more streaks on the water lying on the beach.

Opposite

The finished painting. After standing back to look at the painting, I noticed that the headland did not align with the horizon, so I mixed burnt umber and ultramarine to straighten it.

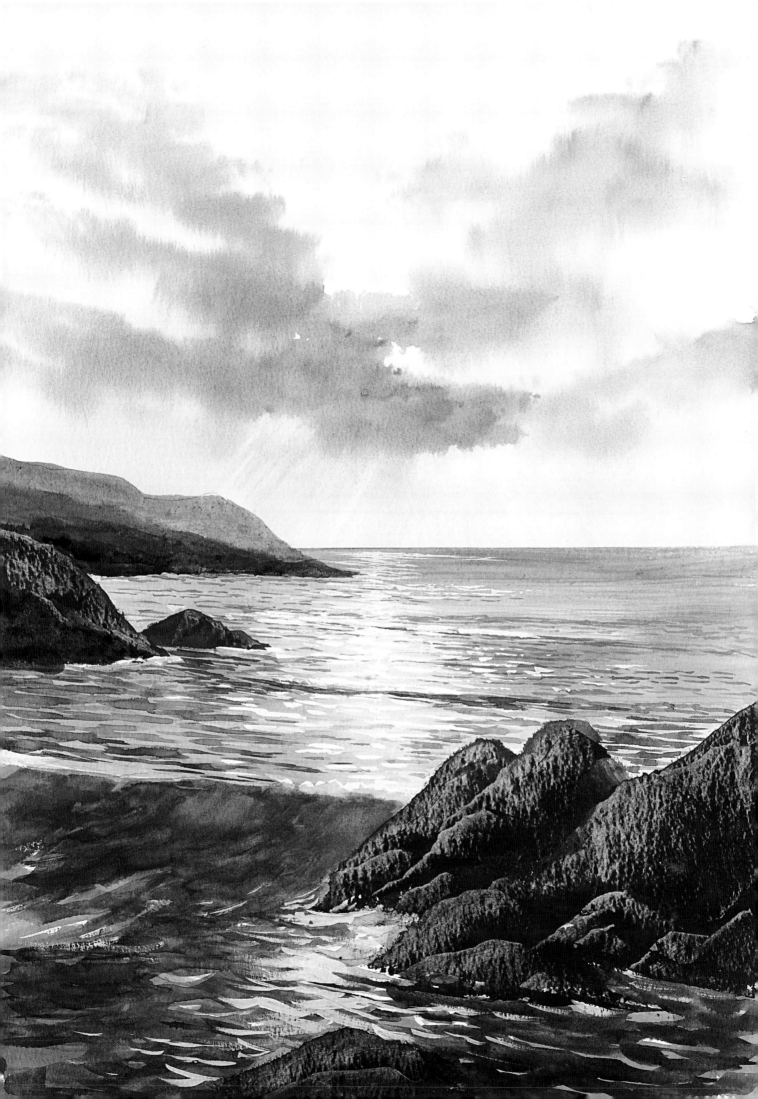

Index

Golden Coastline

The rays of the sun were created using the lifting out technique. The hard edges of the clouds over the sun were achieved by painting wet on dry. The masking of the horizon with masking tape allows you to preserve the sliver of sunlight. The reflected light on the water was painted on first, and the darker tones on either side were added using a darker wash, then darkened further by adding small horizontal brush strokes to represent ripples.

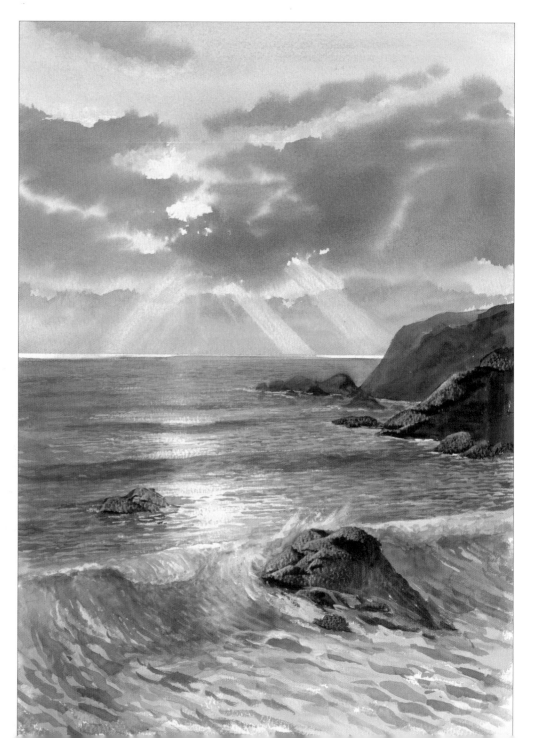